WATERCOLOUR
— PAINTING —

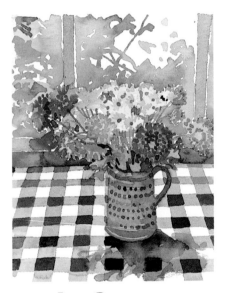

IAN SIDAWAY

Reader's Digest

Published by The Reader's Digest Association Limited
London ● New York ● Montreal ● Sydney ● Cape Town

A Reader's Digest Book

Published by The Reader's Digest Association Limited
11 Westferry Circus
Canary Wharf
London E14 4HE

ISBN 0 276 42390 9

This book was produced by
Design Eye Ltd
The Corn Exchange
Market Square
Bishop's Stortford
Herts CM23 3XF

Craft Plus Publishing Ltd (design & editorial)
Chris Linton (photography)

Printed and manufactured in China

CONTENTS

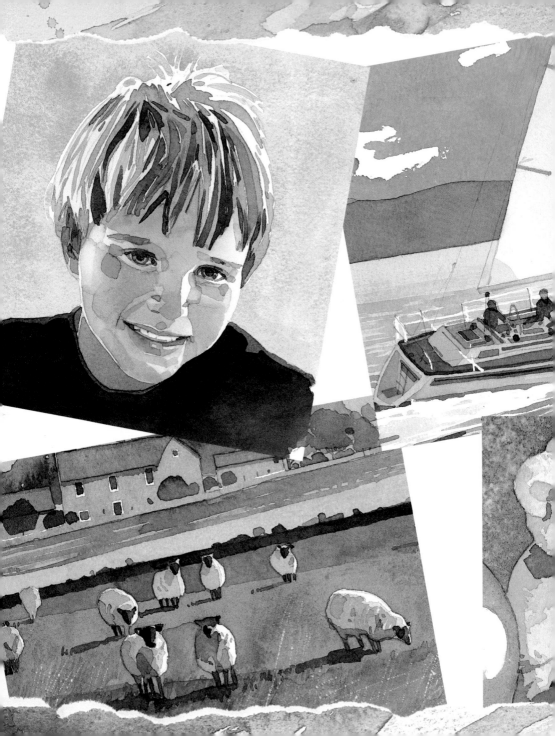

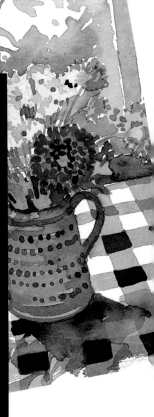

INTRODUCTION

Watercolour painting holds a special appeal and fascination to all people. Part of its attraction lies in the apparent ease with which results can be achieved, and by using the components from this book you will quickly master the art.

There are certain principles to be followed in order to achieve success. Once you have mastered the different techniques, practise your skills by keeping a sketchbook. You will quickly discover why watercolour is an enthralling and popular medium.

There is a wide selection of watercolour materials available, many of which are included in your kit. Here, learn how to select and prepare your equipment, and how to make your own portfolio to protect your finished paintings.

WATERCOLOUR PAPER

Hot Pressed paper

Choose suitable paper from the three types of watercolour supports available in art shops. 'Hot Pressed' paper has a smooth finish, 'Cold Pressed' or 'Not' has a regular texture, and 'Rough' paper has an uneven surface. Hot pressed paper is used for work in detail, Not papers give the best general surface and Rough papers are mostly used for landscapes.

Cold Pressed paper

Several sheets of watercolour paper are included in your kit, and you will need to 'stretch' these before you begin painting (see opposite). All papers are 'sized', coated in a solution of gelatine, to aid paint absorption.

Paper is also described by weight. Heavy, textured papers are best for watercolour, although thinner paper can be used. You may find that lightweight sheets wrinkle when wet, so it is important to 'stretch' them before you begin.

Rough paper

gummed tape

6

STRETCHING PAPER

To stretch your paper, lay it onto a board and cut four lengths of gummed tape from the kit. Dampen the paper using a wet sponge, then moisten the tape and lay the strips down each edge. Allow the paper and tape to dry naturally. The paper will pull taut as it dries and the glue from the tape will secure it to the board. After completing your painting, release the paper from the board by carefully slicing under the tape.

watercolour paint

PAINT

The paints needed to create the projects in this book are provided in your kit. There are eight colours – Crimson, Scarlet, Lemon Yellow, Golden Yellow, Blue, Deep Blue, Sap Green and Burnt Umber. To help you blend the paint, we have also supplied a moulded palette and colour mixing charts on the poster. When recreating the colours from the main chart, mix approximately 60 per cent of the basic colour running vertically down the chart to 40 per cent of the colour running horizontally. Add water to lighten your mix, or more paint to intensify it.

PENS AND PENCILS

An HB pencil is useful for drawing your initial image; it creates a pale line that will generally be obscured by the paint. Water-soluble coloured pencils can also be used for initial lines. When these are wet, they act like paint and the colour can be spread with a brush.

moulded palette

BRUSHES

Two medium-sized brushes are included in your kit; these are perfect for starting your first paintings. However, should you wish to work on large-sized images, you will find that a large round, or a flat brush makes washes easier to apply. For detailed brush strokes, you will need a fine round brush.

HB pencil

brushes

water-soluble pencils

CROPPING LS

The cropping Ls included in your kit will help you to decide on the composition and format of your painting. Refer to page 17 for more detail on how they are used.

cropping Ls

ADDITIVES

Clean water is all that is required for watercolour painting, both to dilute colours and to clean your brushes. However, there are two additives – oxgall and gum arabic – that will help you to achieve certain effects more easily. Both are readily available from art shops, and a small bottle will last you for a long time.

Oxgall is a wetting agent. Add a few drops to your mixing water to extend the time it takes your washes to dry. Oxgall reduces the problem of 'puddling' on heavily coated paper. This is when the size repels a wash, making the layer of paint lie in puddles.

Gum arabic is added to paint mixes in order to increase their transparency; this is desirable when decreasing colour to add highlights. Paint mixed with gum arabic stays soluble when dry, so it can be repeatedly wet and manipulated, or removed from the surface of the paper.

water jar

sketchbook

gum arabic

paintbrush

paint

ASSEMBLING YOUR PORTFOLIO

It is very important that you keep your paintings, and review them over a period of time. Sketches are a valuable source of material that you can work up into finished drawings, or use to try out new techniques. Your watercolour style will change over time – looking back can show you how you have progressed, and remind you of which methods worked best. In your kit are the components you need to make a portfolio for your smaller paintings.

▲ Cover the two sheets of 2mm (⅟₁₆in) thick board from your kit with decorative paper. Neaten and fold the edges and secure them to the boards with PVA glue. Re-punch the holes on the left-hand side and define the scored line by lightly moving the back of a craft knife along it.

▲ Place the boards together, with the scored sheet on top. Thread ribbon through the holes and tie. To include your painting, punch holes along the edge of the paper. Remove the top board, place the painting inside and re-thread the ribbon.

ESSENTIAL PRINCIPLES

Before you begin painting, you will need to learn about, and experiment with, the basic watercolour techniques. Here, we explore mixing paint and how colours work together, creating washes, and the importance of composition and perspective.

COLOUR THEORY

Red, yellow and blue are primary colours (see the colour wheel below); these cannot be mixed from other colours. Orange, green and violet are secondary colours, which are made by adding equal parts of any two primaries. Tertiary colours are made by mixing together a primary colour with the secondary colour closest to it on the colour wheel, giving a red/orange, orange/yellow, yellow/green, green/blue and so on.

COOL COLOUR WHEEL

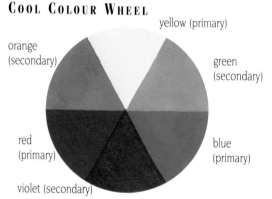

yellow (primary)

orange (secondary)

green (secondary)

red (primary)

blue (primary)

violet (secondary)

◄ Colours that fall opposite each other on the wheel are known as complementary colours, for instance the complementary of red is green. When a little of a colour's complementary is mixed with it, the main colour is subdued.

► Warm colours are red, orange and yellow; cool colours are green, blue and violet. However, as the wheels show, every colour has a warm and a cool variant. Crimson is a cool red because it has a blue bias, whereas green containing a large amount of orange is considered warm.

WARM COLOUR WHEEL

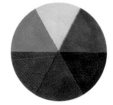

THE USE OF COLOUR

Light affects how colours appear to the human eye. This is particularly important when painting because it can create an exciting range of tones and subtle shades.

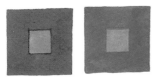

▲ Complementary colours look more vibrant when placed next to each other, than when beside their neighbour on the colour wheel.

▲ A large area covered with a cool colour, blue, creates a receding effect whereas the warm colour, orange, appears dominant, as if advancing towards the viewer.

MIXING COLOUR

Use your palette to mix colours. Squeeze a little of each colour you plan to use on to your palette. Dip your brush into the paint and take it to your mixed colour rather than adding it directly from the tube. Add more paint to darken a shade, and more water to lighten it.

▶ Experiment with paint by creating new colours, making notes in a sketchbook so that you have a record of how you arrived at a particular shade. For instance, by mixing deep blue and crimson you will make purple. For a neutral colour, such as grey, you will need to mix sap green and crimson.

◀ Follow the colour charts on the poster when mixing your paint. To create forest green, blend 60 per cent of the basic blue, the colour running down the chart, with 40 per cent of the golden yellow, the colour running crossways.

WATERCOLOUR WASHES

The term 'wash' implies a relatively broad area of paint applied flatly. To create a wash, load your brush with paint and sweep it across the paper horizontally back and forth, working down your area and allowing the paint from each stroke to mingle with the next.

▶ A flat wash of colour is occasionally used when painting a skyscape, but such a uniform result is seldom required. It is a good idea to use a large brush to achieve this effect.

◀ The colour intensity in a graded wash either gets darker as more paint is blended into the mix, or lighter with the addition of more water. Too much water can create a stippled effect.

▶ When coarse paint granules are used, a granulated wash occurs because the granules separate from the mix. This effect can be useful when painting atmospheric landscape images.

◀ A variegated wash is similar to a graded wash, achieved by adding more paint or water, but it contains at least two colours. Mix the colours separately, beginning with one at the top and adding the others in turn allowing them to merge naturally.

WATERCOLOUR TECHNIQUES

Watercolour images are created by adding paint in two ways. The 'wet-on-dry' technique is when a layer of paint is applied to the paper and allowed to dry before the details are added. 'Wet-on-wet' is when the paint is not left to dry before the next colour, or layer, is added. Usually both techniques will be used in a painting.

When working wet-on-dry, the resulting image should be clean and sharp. The brush should not be overloaded with paint in order to maintain directional strokes. Wet-on-wet images have a much softer, more blended feel than wet-on-dry.

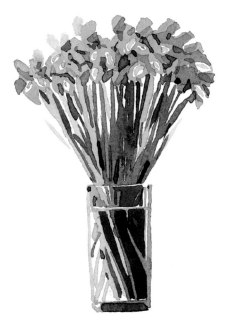

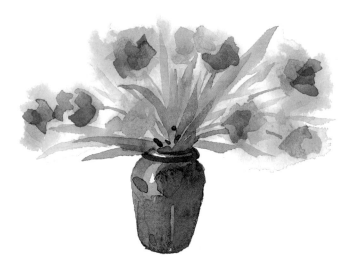

▲ **Wet-on-dry** Use this technique when creating the irises. To add detail, apply more paint into, over, or adjacent to the previous layers.

◀ **Wet-on-wet** Employ the wet-on-wet technique for this arrangement of flowers and foliage. The result is delightfully vague due to the way the brush marks merge.

PROPORTION AND FORM

When constructing the first lines of a drawing it is easy to misjudge angles and the size of objects, but don't be disheartened as accuracy will come with practice. Once these lines are in place you can develop your two-dimensional items to create realistic images.

◄ When drawing any shape, look at its angles and try to determine how it is formed. Practise drawing difficult shapes by breaking them down into simpler ones, such as rectangles, until you feel happy with your illustration.

◄ Colour and tone are used to create an impression of a three-dimensional object. This is achieved through imitating the relative colour tones (lighter and darker shades of a colour) caused by light falling on the object.

► To maintain the overall proportion of an image, measure the size of all objects in relation to each other. Hold up a pencil with your arm outstretched and align it with the subject you are drawing. Next, slide your thumb down the pencil to take a measurement. This is a quick way to compare relative distances.

PERSPECTIVE

By understanding the principles of perspective, an artist can create a three-dimensional illusion on a flat surface. It also relates to the way lines and angles are represented and translated from an actual image on to paper.

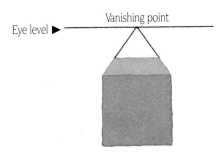

Eye level ▶

Vanishing point

Linear perspective This means that any lines which run parallel to each other, and away from the viewer, will appear to meet at a specific point, or points, on the horizon – the vanishing point. It has two subsidiaries, one-point and two-point perspective.

◀ **One-point perspective** This is when two parallel lines travel away from the viewer and appear to meet at one common vanishing point on the horizon.

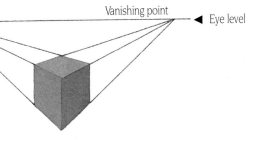

Vanishing point

◀ Eye level

▶ **Two-point perspective**

When two sets of parallel lines travel away from the viewer at opposing angles, and appear to meet at two common vanishing points on the horizon, it is called two-point perspective.

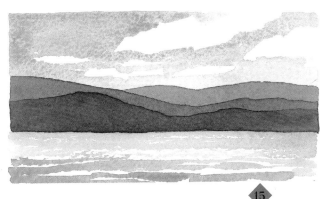

Aerial perspective

◀ In order to create aerial perspective the artist uses both colour and tone, which become paler when they near the horizon; detail is also lost. In the foreground, tones are stronger and textures are more clearly defined.

COMPOSITION

The composition of a picture controls the direction of the viewer's eye, manipulating and influencing how your overall image is seen. It also determines balance and harmony within a painting regardless of the size and format with which you choose to work.

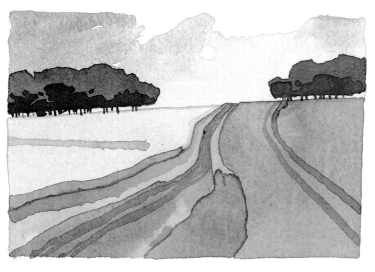

◀ Open composition
Where elements continue beyond the picture area, the composition is known as 'open'. Landscape scenes lend themselves to this format because only a fragment of the entire image is portrayed. In this picture, the viewer's eye is drawn up the track by converging lines and the break in the trees.

▶ Closed composition Where all the objects in the picture are contained within its boundary, and the viewer's eye is led around the whole painting, the composition is called 'closed'. In this example the main item of interest, the highly detailed flowers, is completely contained by the paper. Its shaded creases and even its shadows fall within the picture's area.

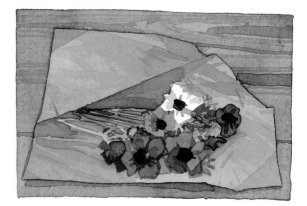

► Your cropping Ls can be used to form an adjustable viewfinder, as well as to assess and check your composition. They are useful when deciding which portion of a scene to paint. Move the Ls into a rectangle; this limits your view of the entire scene, and enables you to focus on a smaller area.

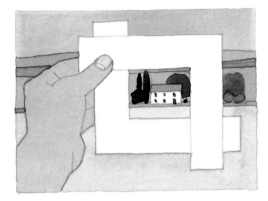

You may find it helpful to make a series of initial thumbnail sketches to explore a few alternative compositions. These can be made in your sketchbook for future reference. As well as indicating any problems before you begin painting, you will find that making these sketches is good drawing practice.

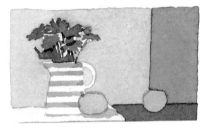

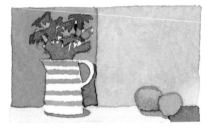

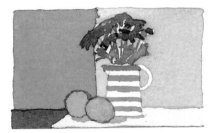

▲ Composition is affected by where the main subject is placed. The top two images look awkward because they have split focal points, which are distracting.

◄ This is a perfect composition because it has a strong central image, the jug and fruit, which creates a rounded ensemble.

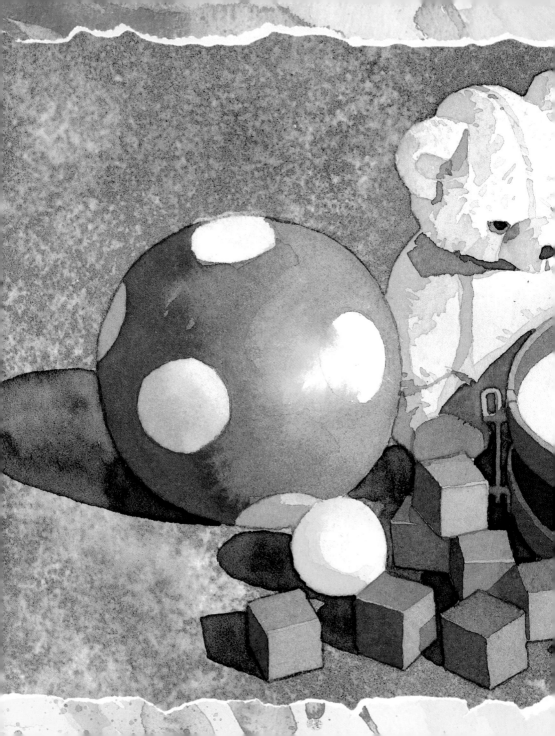

STILL LIFE

There is an enormous choice of subjects for still life painting, and as each item is specifically chosen by the artist, he or she has total control over composition and perspective.

In this chapter you will find still life projects that enable you to practise your watercolour technique to show texture and detail – a fruit bowl, a group of toys and a jug of mixed flowers. As you progress, create your own still life compositions with the objects around you.

S T I L L L I F E I N D E T A I L

One of the delights of still life painting is capturing the realism of a subject by using a variety of watercolour techniques. Keep your eyes open for suitable objects to practise painting, and to use in your compositions.

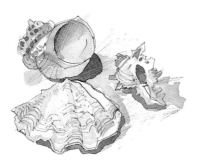

◀ **Shells** A few quick washes describe the colour, shape and shadowing of this group of shells. Once the wash dries, the exact outlines and details are carefully added using soft graphite pencil.

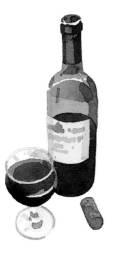

◀ **Glass** When painting glass objects, keep washes simple and do not over-emphasise reflections. Note how the surface of the glass is influenced by surrounding items and adjacent colours. Take care to create crisp highlights using masking fluid (refer to your poster for details) as these suggest the hardness of the material.

▲ **Fabric** A 'dried' brush worked over a combination of washes can suggest texture. Load your brush, squeeze out most of the paint, and apply it in directional strokes.

◄ Paper Lead and coloured pencils work well with watercolour. Here, a few scribbled areas of HB pencil are used to suggest the crumpled tissue around a bunch of daffodils. Pencils can be used beneath, or over, washes to add textural relief to flat areas of colour, and to define detail. Avoid overworking the pencil lines as they can overshadow the paint.

► Tools and vegetables These tools, gloves and carrots are worked in dull colours to indicate their worn appearance. The wooden fork handle is given a little extra detail to make it appear above, and on top of, the grey gardening gloves.

◄ Pencil case This still life provides an opportunity to use strong, undiluted paint directly from the tube. Each colour is allowed to dry before placing a different one next to it. This prevents the colours from running together, so they remain clean and pure.

BOX AND BOWL

You can choose any number of items when creating your still life. However, try to include subjects such as glass, wood and fruit which will give you a wide variety of surface textures and shapes with which to practise.

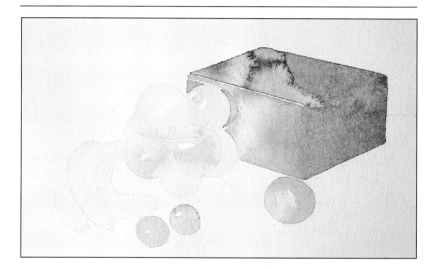

▲ 1 Firstly you will need to make a light pencil drawing as a guide. Using a flat brush, cover these lines with several light washes, worked wet-on-wet. Now mix burnt umber, golden yellow and scarlet together and apply a wash on to the box. To create highlights on the fruit and on the top of the glass bowl, leave small areas of white paper showing through the washes.

▲ 2 You can suggest reflections in the box's polished surface by allowing the wash to dry before adding clean water to thin the layer of paint on the paper.

◀ 3 Create an ochre colour for the table top by mixing burnt umber and golden yellow. Refer to the colour chart if needed.

▼ 4 Once your initial washes are dry, rework the fruit using mixes of lemon yellow, golden yellow, scarlet, crimson and sap green. You will need to mix crimson and deep blue for the plums. Use a mid-brown colour for two sides of the box, and leave a light line where the lid joins.

▲ 5 Give substance to the bowl by adding layers of light grey paint. Note how the colours of the bananas and box are lighter when seen through the glass bowl.

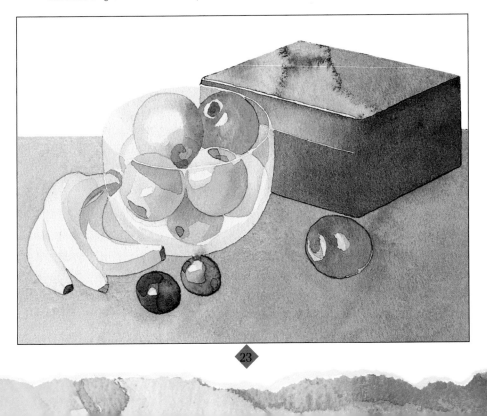

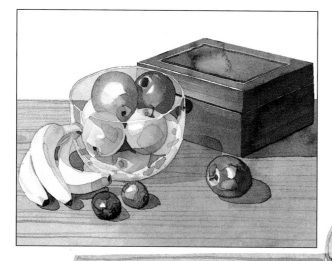

▲ 6 You will now need to
add detail to your painting
with a round brush; darken
the side of the box and fruit
to give them a sharper
quality. Paint a dark brown
line with the tip of your
brush to emphasise the join
between the box and the lid.

7 You can give a grainy feel
to the table top by applying
a light ochre wash, and
then creating subtle lines
with a brown pencil.

◄ 8 Continue to increase the illusion of depth by painting darker, more intense lines of colour around the edges and in between the pieces of fruit.

▼ 9 Finally, anchor the fruit bowl and box to the table by adding shadows made from a blend of brown and black, with added crimson and blue.

TIP

Gather a few everyday objects such as hats, glasses or garden tools and position them on a piece of cloth, paper or board. You will find it useful, especially at first, to have a strong light source when painting still life.

TOY PICTURE

The highlighted objects and thrown shadows in this still life will enable you to practise depicting light and shade. You will ideally need to buy gum arabic for this project, and may find it helpful to refer to the poster for how to use it to good effect.

▼ 1 Draw your outline and, using it as a guide, establish the colour of the toys with a variety of washes using a flat brush. Concentrate on one colour at a time, to avoid having to constantly rinse your brush.

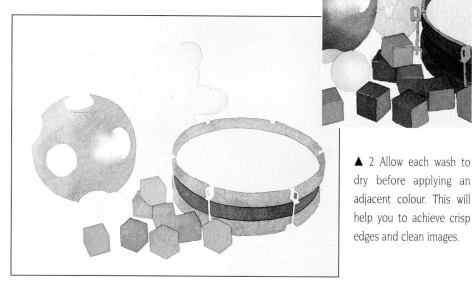

▲ 2 Allow each wash to dry before applying an adjacent colour. This will help you to achieve crisp edges and clean images.

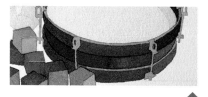

◄ 3 To create the shadows, apply a mid-red wash, then add a darker red over the top. The colours will run together creating natural shading.

▶ 4 To achieve the highlights on the balls, brush water over the paper and, using a darker colour, paint adjacently to the wet area. Once the paint touches this, it will spread, becoming less intense as it is weakened by the water.

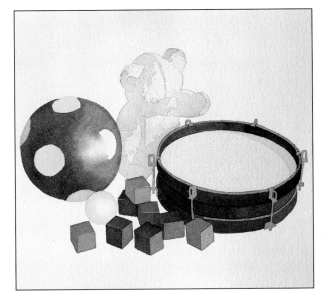

◀ 5 Mix crimson and blue for the carpet, adding gum arabic so it can be re-wet. Refer to the colour chart as a guide to blending colours by this technique. If you do not wish to use this method, sponge the paint sparsely.

6 When creating the mottled effect on the carpet, use a wet sponge and dab it onto the paper to remove patches of the paint and gum arabic mix.

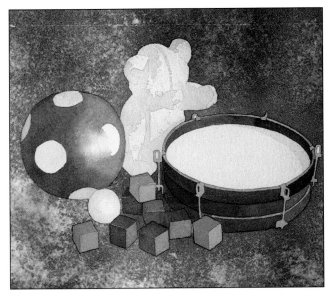

▲ 7 Paint the bear's fur using four different tones of ochre, allowing each layer to dry before painting the next. Use the darkest shade for the details such as the eyes, and subtly create the shading on the ears, head and shoulders using the lighter tones.

► 8 You can create the shadows on the blocks and drum skin by using more intense colours such as dark ochre. Add the shadows thrown across the carpet with a deep purple wash.

T I P

When painting a still life, note that daylight throws a much stronger light than a lamp. Watch how shadows grow or reduce according to the angle of the light source, but do not allow them to dominate your image by using colours such as black that are too dark.

The variety of colours included in this project will allow you to experiment with the different paint mixes, as shown on the colour charts. You can also practise your wash techniques using a flat brush, and adding detail with a round brush.

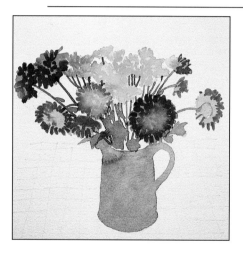

▶ 3 Use a blue-brown wash to create the earthenware look on the jug. Then allow this to dry before painting on the pattern and adding the shadows in dark brown.

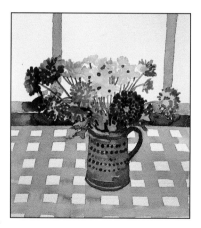

▲ 1 Apply initial colour washes over your pencil outlines wet-on-wet, allowing the paint to run slightly. Create the flower petals by brushing water over the washes and dropping paint on to the paper.

2 Paint the window-sill dark brown and the lead bars and tablecloth checks light grey. Brush over the flowers with water; allow to dry a little before adding stronger colours.

▲ 4 Strengthen your initial wash lines for the check pattern with a mix of sap green and lemon yellow. Finally, add the foliage outside the window using shades of green.

Once you have mastered the basics of watercolour, you can experiment with more difficult techniques such as 'mixed media' for unique results. Select challenging subjects too, and manipulate their perspectives to create a different visual effect.

▶ Pastels and paints make excellent partners, and such 'mixed media' images can look very successful. Soft pastels are sometimes used to lighten dark washes, which are difficult to alter with additional layers of paint. Once the initial wash is dry, make a pattern of small marks, known as 'stippling', over the top of the paint with the pastel. This technique has been used here to add highlights to the leaves.

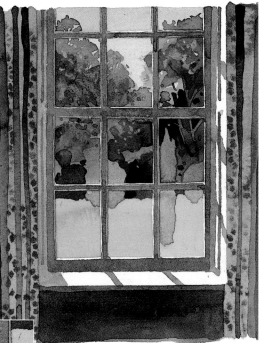

◀ Create decorative patterns with a stencil or mask. Here, the curtain has been painted with a wash and then overworked through a paper cake doily using an orange pastel.

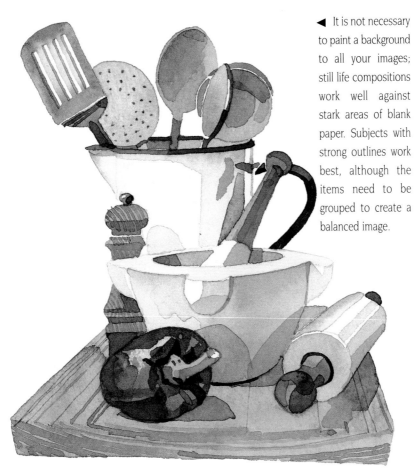

◀ It is not necessary to paint a background to all your images; still life compositions work well against stark areas of blank paper. Subjects with strong outlines work best, although the items need to be grouped to create a balanced image.

◀ If objects are viewed from a certain angle, the apparent distance and space between them disappears and they can look flat. Experiment by altering the position of the items to make the angle between them more conspicuous. Use your background to exaggerate the perspective of your subject.

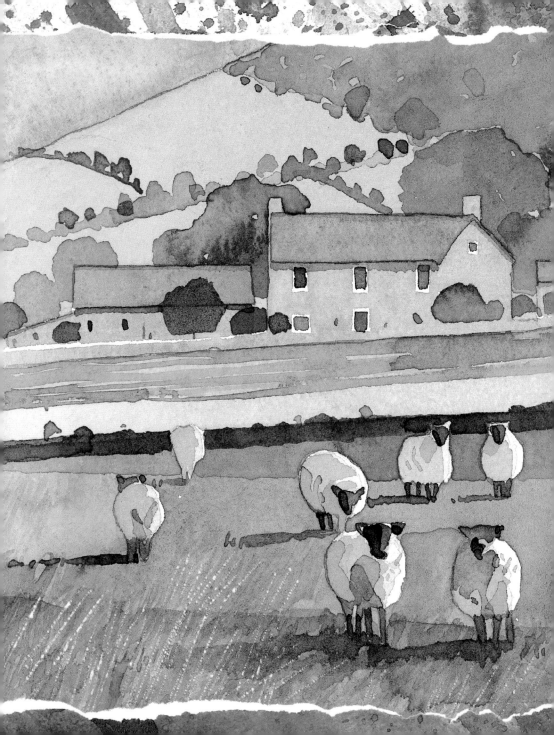

LANDSCAPES

Watercolour is particularly suited to landscape paintings because wash techniques superbly render the mood of an ever-changing scene. Whether sketching quickly on location to capture a fleeting impression, or painting meticulously at home, you can easily achieve satisfying results.

In this chapter we show how to draw architectural details, capture the tranquillity of a farm scene and create a sense of speed with a boat. Advanced techniques such as brush ruling are also used.

By simply altering your brush style or wash in a landscape painting, you can hint at specific seasons, weather conditions and times of day. However, although a basic image can be vague, this style of painting can also include an immense amount of detail.

◀ **Clouds** Remove wet paint with blotting paper to create cloud formations. Clouds can contain a kaleidoscope of colours which make them ideal for conveying weather conditions.

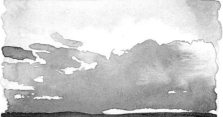

▶ The orange cloud is worked wet-on-dry over a variegated wash. Skyscapes are also used to suggest perspective; leave blank areas of paper to represent clouds rather than painting over the entire paper.

▼ **Trees** Use fine brushes and pencil for winter trees, a small piece of sponge for canopied deciduous trees, and try a chisel-shaped piece of card dipped in paint for conifers.

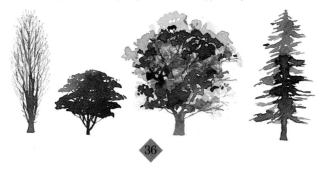

► **Figures** The human form adds a tangible sense of movement to a scene; at a distance figures show little or no detail. Here, a few flicks of a brush are sufficient to create the impression of people relaxing on a beach.

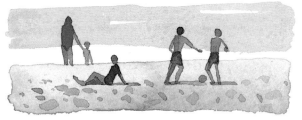

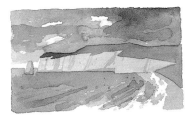

▲ **Weather conditions** The same scene can look very different depending on the weather conditions, season and time of day. Given the often fickle nature of the weather, changes can take place in a matter of minutes. Revisit places and take photographs at different times, then experiment with watercolour techniques to capture the various moods.

► **Sketching** When on location, work with small images and a limited palette. This will enable you to make several sketches and colour notes that can be worked up later. You can then experiment with brush and paint techniques to recapture the mood and drama of the scene.

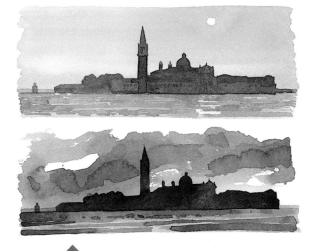

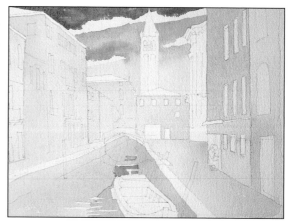

You can create a landscape largely in wash, but take time to measure the angles and perspectives to help lead the viewer's eye through the image. Once the washes have been applied, add the intricate details which will lift the whole scene.

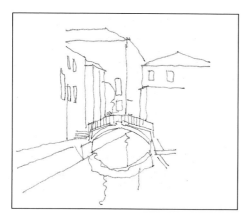

◄ 1 Establish the perspective of the image with a faint outline drawing, using a soft pencil. Try not to press too hard – or the lines will show through your washes.

2 Check your perspective carefully. Erase and redraw your lines until you feel they are right. This will help to correct any buildings that appear to be leaning at unusual angles.

► 3 Using a flat brush, paint the sky with a deep blue mix, allowing the watercolour paper to show through for clouds. Weaken the blue between the buildings by adding water to the paint. For the buildings, apply ochre, burnt umber, terracotta and grey washes. Add a neutral mix of deep blue and brown for the walkways and walls of the buildings.

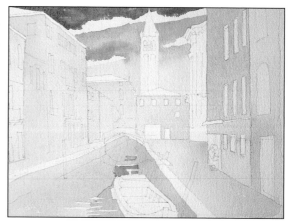

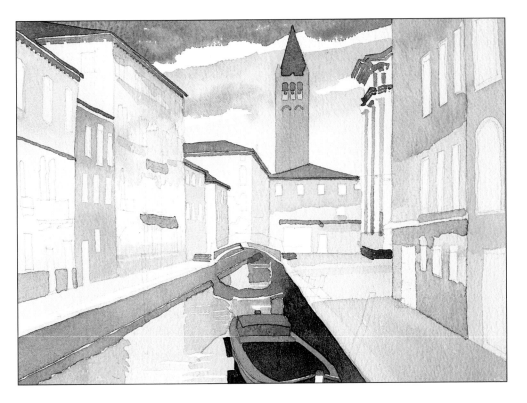

▲ 4 Apply solid areas of dark terracotta and burnt umber for the rooftops. To give the picture depth, pick out the shadows with contrasting dark greys and browns.

◄ 5 Using a round brush, bring the gondola into the foreground with bright red and blue paint. Create the black interior with a mix of deep blue and burnt umber.

▼ 6 To make the plastered walls of the buildings look distressed, paint small areas wet-on-dry, use the tip of the brush. You can also use a sponge or crumpled tissue to scrub, or 'scumble', a layer of wet paint over areas of the already dry image.

▼ 7 Allow the layers of paint to dry before you add the detailing with the tip of a round brush. Paint the windows and shutters on the distant buildings with thin, weakened shades of colour, and the details in the foreground using strong, darker mixes of paint.

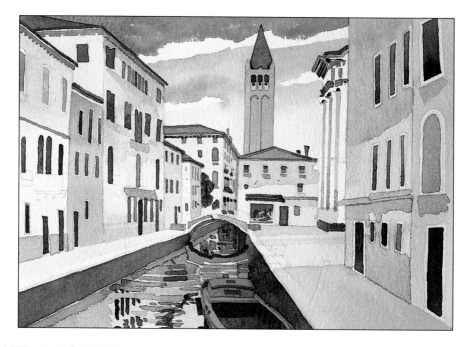

◄ 8 Re-use the colours of the buildings, or as near an exact mix as you can recreate, for the reflections. Be careful not to make them too dark, or they may become too dominant. Work these reflections wet-on-dry so that the brush strokes remain crisp and sharp.

► 9 Indicate the mooring stakes, the balconies, the paving slabs and the few distant figures in dark greys and browns with just the tip of the brush.

▼ 10 Finally, paint the window boxes with quick brush strokes in dark and mid-green paint. There is no need to portray every detail, the aim is merely to give a suggestion of their form.

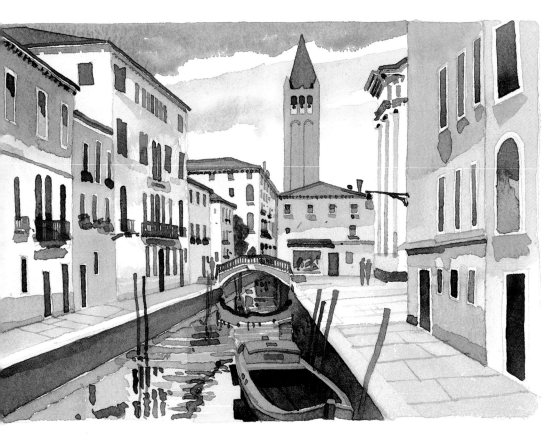

Farming images can be exciting as landscape subjects because you can extract a small area of nature and translate it to the page in your own style. You can also experiment with this project to master the art of sgraffito.

1 When you are making your initial pencil outlines, position the farm buildings beneath the hill, halfway up the painting.

▼ 2 You will need to apply a grey wash for the buildings and dry stone walls, mixing this from burnt umber and blue paint. When you have completed the washes, darken this colour with deep blue for the slate roofs.

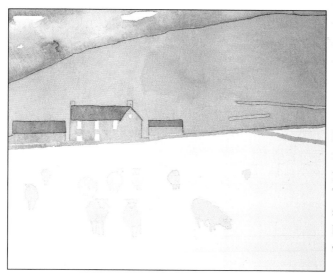

3 Establish the distant hillside with a wash made from sap green, lemon yellow and burnt umber. Then create the stormy sky with a deep blue and burnt umber wash worked wet-on-wet.

◄ 4 Paint the sheep using three subtle tones of brown. Add the darker details with an almost black mix of burnt umber and blue. To create a more accurate image, you can later modify the shape of the sheep when you paint the green field.

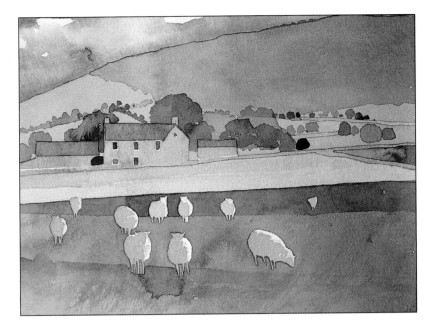

▲ 5 To add depth to your painting, darken the green wash on the hillside with a mix of sap green and burnt umber. Now add the hedgerows and trees in the distance using the same colour. Work a small amount of scarlet into the mix to create the warm green of the field in the foreground.

◄ 6 Once the washes on the hills and hedgerows have dried, add intricate details such as extra trees and the individual blades of grass in the foreground. Then apply an ochre wash across the middle ground in front of the farm buildings.

▲ 7 Gradually build up more layers of trees and shrubbery with various mixes of green, brown and scarlet. Then add the rough shadows thrown by the sheep in dark green.

8 To create the impression of coarse grass, scratch back the paint in the foreground with the point of a craft knife to reveal the white paper. Refer to the colour chart for more detail on this technique called 'sgraffito'.

TIP

You will find that farms around the country provide very different subjects. Take photographs when you travel, and extract elements from different scenes to add to your final landscape.

SAILBOAT

This water-based image reflects a sense of movement using subtle brush strokes, and incorporates the use of masking fluid to create the spray and wake left by the boat. Refer to the colour charts on the poster for more information before beginning this painting.

1 Once you have drawn your pencil lines, place strips of masking tape over the areas for the sails and hull. This will ensure that the white paper is concealed when you apply the paint.

▶ 2 To create the impression of the boat passing through the water, paint masking fluid around the boat, using the tip of a round brush.

3 Paint the sea using a flat brush and a blue wash. Work the sky in a darker blue, leaving the clouds as blank paper. Paint the boat using a round brush for the detailing on the hull and the figures.

◀ 4 Finally, peel off the masking fluid and tape once the paint is dry, and flick pale blue on to the paper for the final layer of spray.

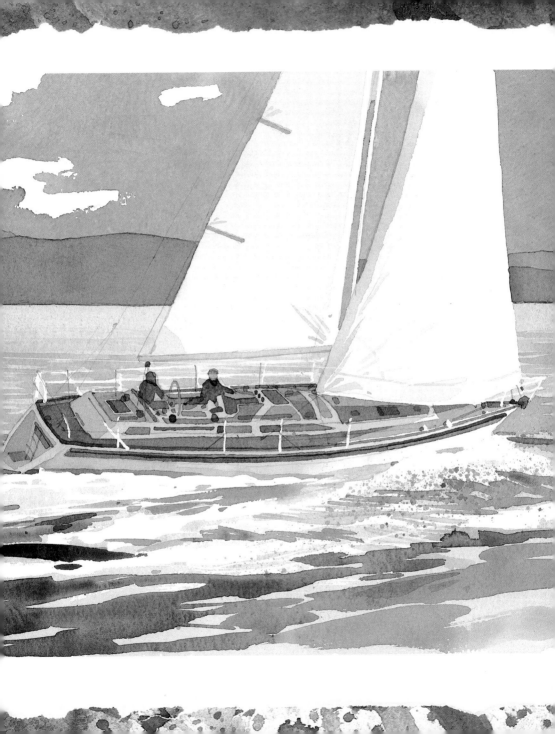

Details can easily be incorporated into landscape paintings using a minimum of watercolour techniques such as brush ruling, adding masking fluid and using salt crystals. Refer to the colour chart on the poster for additional explanations.

▼ This finished picture has a dramatic feel to it, with its strong central image. The early evening sky is captured with a variegated wash using a range of neutral greys and browns.

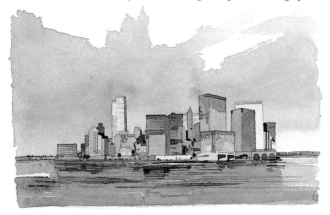

◀ 'Brush ruling', a series of straight lines created with the tip of a brush and ruler, is used to create the rows of tiny windows and crisp building edges. Place the ruler onto the painting with the top edge lifted at 45 degrees, then run the brush along its edge.

▶ The reflections in the sea are painted wet-on-dry using layers of paint that get progressively darker. Once dry, the darkest ripples are made by painting the edge of a ruler and pressing it on to the paper.

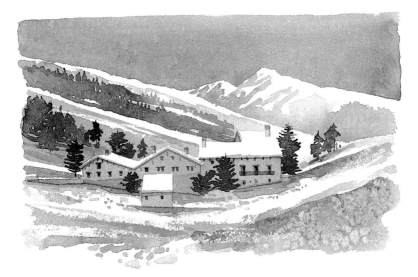

▲ Forward planning is an important part of watercolour technique because substances such as wax and salt crystals may need to be added to the paper before the paint is applied. However, you will need to establish the faint position of the buildings in pencil first before deciding where to place the wax, salt and masking fluid.

▲ To create a snowy feel, flick spots of masking fluid over the paper with a toothbrush and peel off once the paint has dried.

▼ Scribble a wax candle over the areas of drifting snow, taking care not to cover parts of the paper where you want the paint to be absorbed.

▲ Sprinkle a few salt crystals over the shadows of the snow while the paint is still wet. Once it has dried, shake off the salt to leave a frosted pattern.

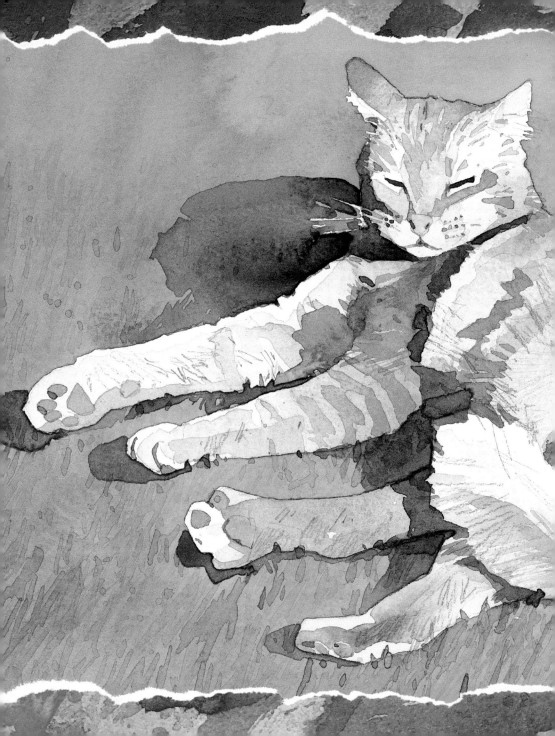

FIGURES

The human figure and portraits, together with animal subjects, are generally considered to be the most challenging subjects to paint. Familiarising yourself with the rules of proportion and simple anatomy will help to make the task easier.

In order to express individuality and character accurately, an artist needs to be very observant. Family and friends often make willing models for portraits, like the child on the following pages; for animal subjects study your pet or visit a local farm.

When concentrating on figure drawings, it is useful to keep a sketchbook with you at all times. Make quick sketches and references in pencil of people and animals around you and transform them into paintings later.

▼ **Figures** Success with figure painting greatly depends on getting the body proportions correct. There are slight variations from person to person, but as a general rule an adult's body is seven times the size of the head.

A toddler's head will fit into its body about four to four and a half times.

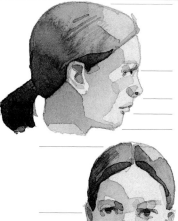

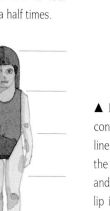

▲ **Heads** The face conforms to a uniform construction. The eyes fall on a horizontal line halfway down the face. The base of the nose falls halfway between the eyes and the chin, while the base of the lower lip is halfway between the nose and the chin. Note how far back the ears sit when seen from the side.

▼ **Animals** Both domestic pets and wild animals seldom stay still for long, so it is unlikely that you will finish a complete painting before your subject changes position. The answer, apart from painting from a photograph, is to make a series of quick sketches, shown here, from which you can put together a painting later.

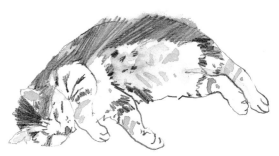

▲ **Sketching** The watercolour pencils supplied are ideal for sketching. They can be worked on with water at a later date, turning your fine line drawings into tone and texture studies.

▼ **Details from real life** A few tones and simple colours are all that are needed to portray these elephants in the wild. Painted at a distance, and in the strong East African light, little detail can be seen.

Try to get as much information into these working studies as you can, and if your subject moves, simply begin again. All of your sketches will prove to be useful as later references.

P O R T R A I T

Focus on portraying the child's mischievous nature in this portrait. Gum arabic is added to several washes to create realistic highlights as the boy's hair flops over the crown of the head and onto his face.

1 Using the brown watercolour pencil, draw as close a likeness as possible to your subject. Do not worry about the intricate details, but make sure that the features are correctly positioned.

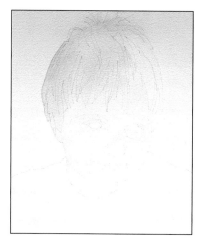

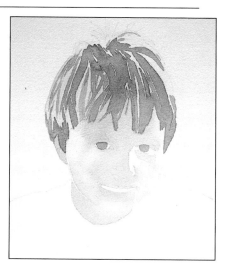

▲ 3 Now apply the mid tones where the hair falls over the head. Make gradual changes in the skin by brushing water over the washes and allowing the colours to blend.

▲ 2 Paint the hair using a round brush and a wash of burnt umber, golden yellow and scarlet. Apply a light skin tone, but do not worry if these two washes run together.

4 To create a realistic image of the child's eyes, blend a light blue-grey wash using burnt umber and blue. Pay particular attention to eye shape when applying the paint.

54

▶ 5 Shade the upper eyelids with a dark red-brown mix. Then add the pupil and iris details with deep blue and burnt umber using the tip of your brush.

6 To heighten the boy's colour use a blend of scarlet, golden yellow and burnt umber for the lips and ear. Darken this colour with blue for the shadow on the neck.

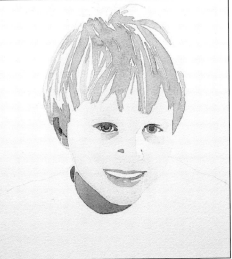

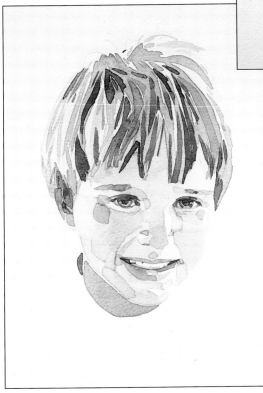

◀ 7 To darken the teeth, inside of the mouth and the whites of the eyes create a warm grey wash and apply it lightly. Mix a flesh tone to darken the cheeks, forehead and around the eyes and nose. Add gum arabic to the flesh colour to make the paint more translucent, enabling you to highlight a few areas and create a sheen.

8 Now paint the lips, allowing the highlights to show through. Give depth to the mouth by adding light grey at the corners.

▶ 9 Sharpen and create a more rounded image by adding darkened areas of paint around, and in, the eyes. Then apply shading around the cheeks.

10 Complete the hair with three tonal washes. By adding gum arabic to the later washes you can adjust and remove colour, styling the fall of the hair as required.

11 Now create a black colour by mixing deep blue and burnt umber. Use this to add detail to the eyes and eyelids. Check that you have made plenty of highlights, removing the layers of paint with water and gum arabic if needed.

12 Finish by painting the boy's sweater, removing thin lines of paint to create highlights on the shoulders and neck.

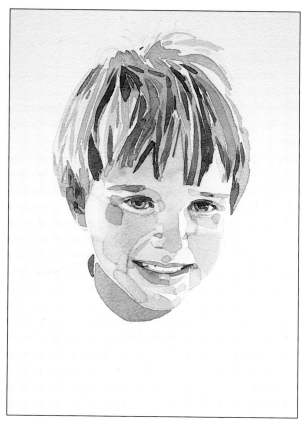

T I P

People of all ages are fascinating to draw, either as line artworks or completed watercolour paintings. Babies are especially challenging, partly because they never stay still, but also because of the proportions of their bodies. Older people can be just as rewarding, particularly if they have weather-beaten faces.

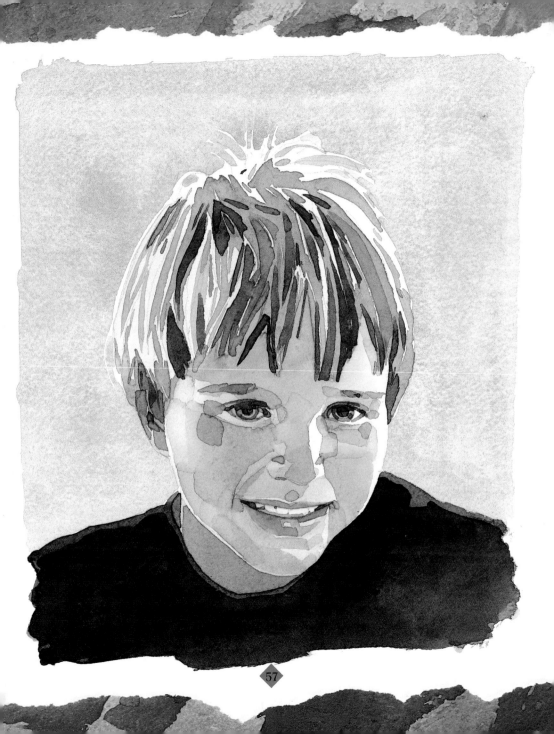

L A Z I N G C A T

This watercolour of a sleeping cat uses a mixed media of both paint and a brown water-soluble pencil. Use the pencil to make detailed strokes for the fur, and apply subtle washes of colour to create the natural shading on the cat's head and back.

▼ 1 Establish the cat's outline in pencil. Now mix two tones of light orange using golden yellow and scarlet; make one slightly darker than the other. Wash the lighter tone over the body area with a flat brush then, working wet-on-wet, apply the darker colour to create patches of fur.

▼ 2 As the wash dries, gently tilt your watercolour paper allowing the paint to 'puddle', or collect, along the cat's back. This will help to create natural shading.

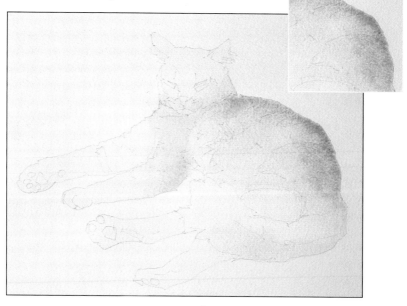

▶ 3 Darken your orange colour with a little burnt umber. Wet several areas of paper on the cat's back, legs and tail with water before painting on the mid-tone patterns. The water will help the paint to run, creating a soft blend of colours.

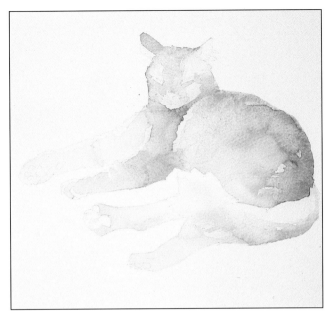

▼ 4 Use a mix of scarlet and burnt umber paint for the nose, before adding a little brown and blue to this colour for the pads on the underside of the cat's feet.

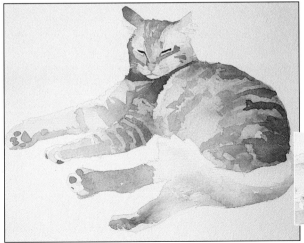

▼ 5 Now darken the orange mix again and when the previous layer of paint is dry, add the striped detailing on the cat's head and legs with wide, sweeping brush strokes.

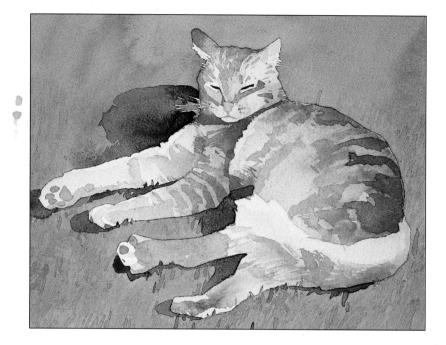

▲ 6 Next create mid green using sap green, burnt umber and a little blue. Brush this over the background area for the grass. Darken the mix with more burnt umber and blue for the shadows. Once this is dry, add the blades of grass and fine fur details using the tip of a round brush.

◄ 7 Further darken the cat's fur by applying a mixture of burnt umber and blue paint for the deep shadows under its chin.

8 Finally highlight the texture of individual cat hairs using the soft brown water-soluble pencil to create fine, random strokes.

T I P

When painting an animal, it is important that it does not appear to be floating. Anchor your subject in a background, however vague, to add realism. To achieve this and to avoid the problem of the animal moving, take a photograph while it is relaxed, then complete the portrait later.

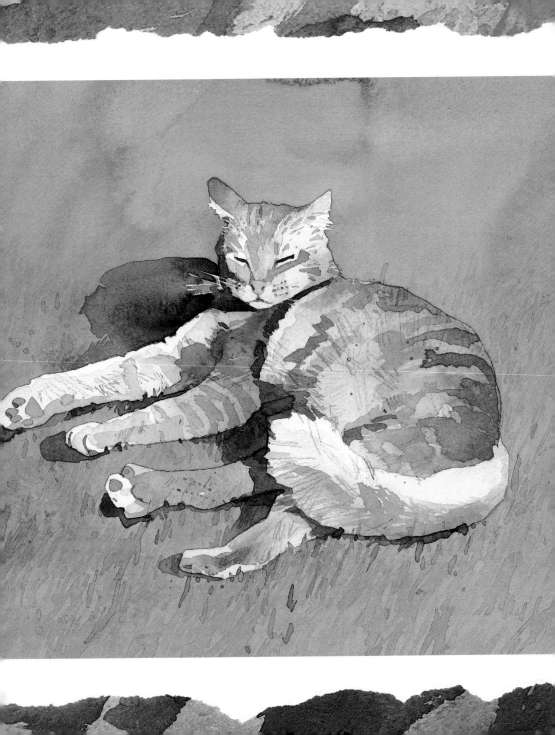

The mood of a painting will influence the viewer's perception of the image, and this can be achieved with a careful use of colour and tone. You can also use colour and tone to create an overall impression of movement without having to paint precise details.

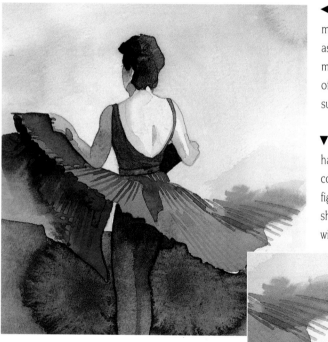

◀ Watercolour paintings are moments frozen in time, and as such they lack any real movement. However, a sense of motion can be created by a subtle use of shading.

▼ Here, the dancer's skirt has been painted with contrasting techniques. The figure is painted wet-on-dry in sharp focus which contrasts with the skirt; this is painted wet-on-wet, which blurs the form and creates a swirling illusion.

The backruns, shaped blotches of paint with hard edges, on the floor contribute to the overall feeling of movement. They are created when paint is applied to a wet wash and the new colour seeps into the old; refer to the poster for more detail.

► All painted images can be seen as a series of optical tricks. From a distance, the viewer will see this dense crowd as a mass of people, visualising the faces in their imaginations. In reality, the artist simply has to create an impression with a series of brush strokes.

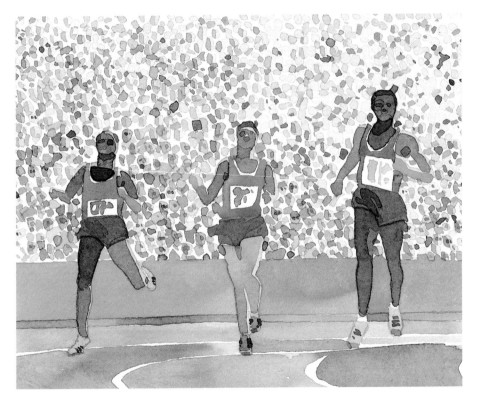

▲ When painting a scene that has close-up images as well as objects in the distance, an artist must concentrate on linear perspective to suggest recession. These runners are painted with bold, more vibrant colours to make them stand out in the foreground.

GLOSSARY

Cropping Ls – Shaped pieces of card or plastic used to make an adjustable viewfinder.

Closed composition – A painting that contains all of its subject matter within the boundary area.

Complementary colours – Colours that fall opposite each other on the colour wheel.

Gum arabic – A chemical that can be added to water to increase the transparency and richness of paint.

Open composition – A painting that has subject elements beyond the picture area.

Perspective – The relationship between a person and an object, or scene, in conjunction with distance.

Primary colours – Red, yellow and blue. These colours cannot be created by mixing other colours.

Scumbling – A technique that involves scrubbing dry paint unevenly over another layer of dry colour.

Secondary colours – Orange, green and violet. These colours are created by adding equal quantities of two primaries.

Tertiary colours – A blend of colours that are created by mixing together a primary colour with the closest secondary to it on the colour wheel.

Washes – Layers of paint generally applied to large areas, usually with a flat brush.

Wet-on-dry – A wash technique where a layer of paint is applied to an already dried area of colour. The result is a clean, sharp image with distinctive brush strokes.

Wet-on-wet – A wash technique where wet paint is swept over another layer of paint that is still wet. This creates a vague image.